# AUGUST REVERIE III
# EXPRESSIONS

Copyright © 2019 Vivid Publishers / Chinthaka Herath
Illustrated by Chinthaka Herath
Design & layout by Intense Media

All rights reserved. No part of this publication may be reproduced, distributed or transmitted in any form or by any means including photocopying, recording or other electronic or mechanical methods, without the prior written permission of the Publisher/ Chinthaka Herath.

ISBN-13: 9781690910008

# INTRODUCTION

Thank you for purchasing the third book in the August Reverie Series: EXPRESSIONS by Chinthaka Herath. In this book you will find 24 expressive female faces in different poses & moods, spanning a full spectrum from happiness to anger, sadness to hope and from calm to excited!

The pages feature beautiful women crafted out in different scenes together with different kinds of animals, with the majority of them framed together in floral adornments.

All art is hand drawn & some shading is included as a guide to add shadowing & lighting.

You can use any coloring medium from pencils to markers as long as they have a fine tip.

*A note on the use of markers:* Even though the illustrations are printed one per page, to give additional protection please place a thick paper or cardboard beneath the page you are coloring so that the ink will not bleed through to the next page.

**Subscribe at our website to get a FREE 10 Page PDF Sampler 'Fantasy Art Adult Coloring Collection' featuring pages from our three adult coloring books August Reverie 1, 2 and Saga: Fire & Water!** Plus, news on discounts, free pages, contests and more!

 www.vividpublishers.com

*We would love to see your completed art. You can reach us at:*

 fb.com/VividPublishers

 @VividPublishers

*Also, we welcome you to join our Facebook group to share your art, see other colorists' art, enter exciting contests plus more!*

 fb.com/groups/VividPublishers

Thank you for your continued support and interest in our adult coloring books. We hope you enjoy coloring the pages as much as we did creating them. Happy Coloring!

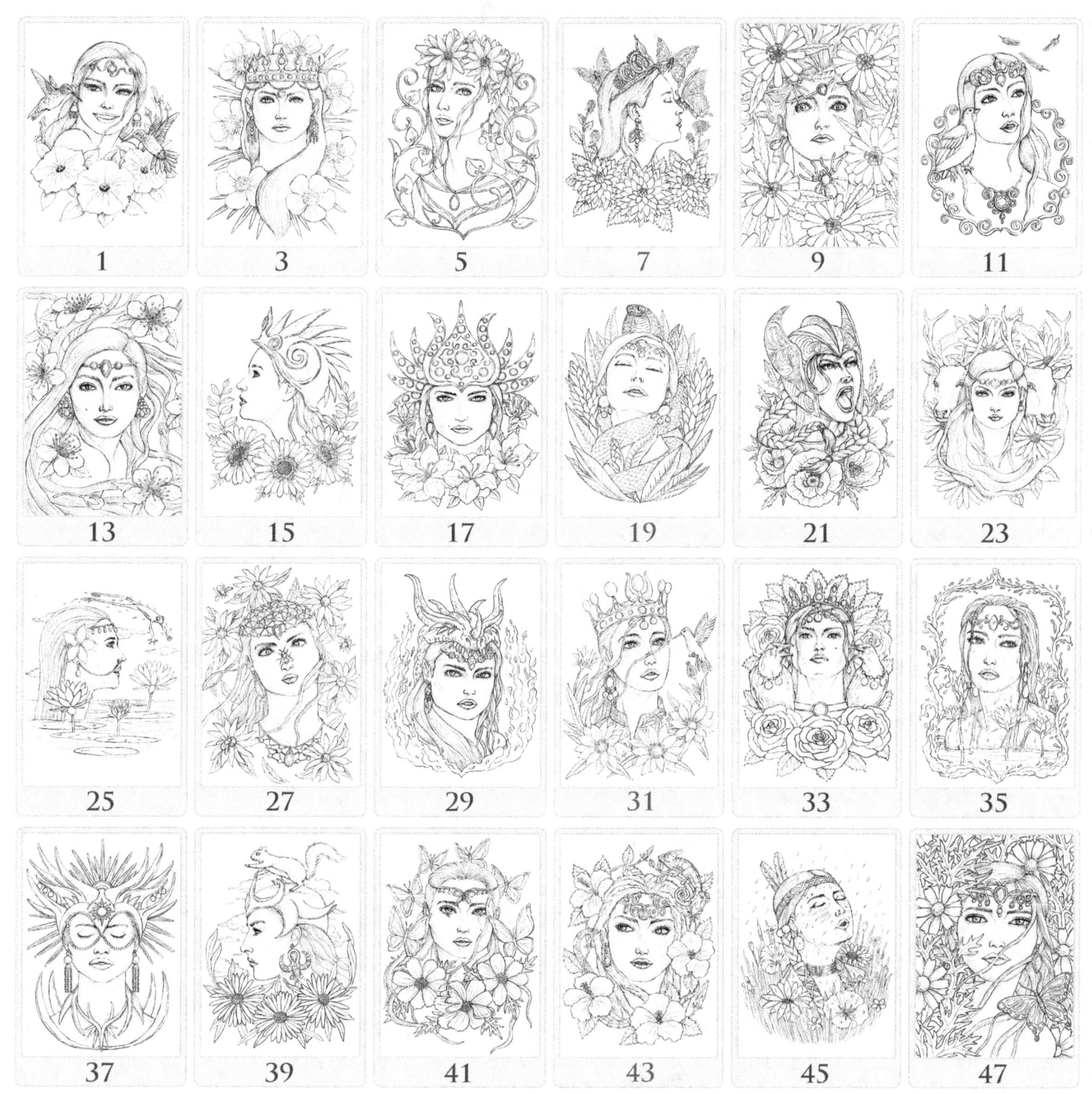

# CONTENTS

1) Chaser of Trochili   3) Auricomus's Stare   5) Arnica
7) Papilionoidea's Dream   9) Spider's Lair   11) Falling Feathers
13) Flowery Gale   15) Faith in the Stars   17) Heavy Crown
19) The Strangler   21) Leona's War   23) Fawn's Deer
25) Princess & the Frog   27) Queen Apoidea   29) Dragon Slayer
31) The Messenger   33) Raven Ruler #2   35) Water's Spirit
37) Savannah Sun   39) The Lookout   41) Queen Lepidoptera
43) Reptilian Queen   45) Red Indian Showers   47) Hide & Seek

# Chaser of Trochili

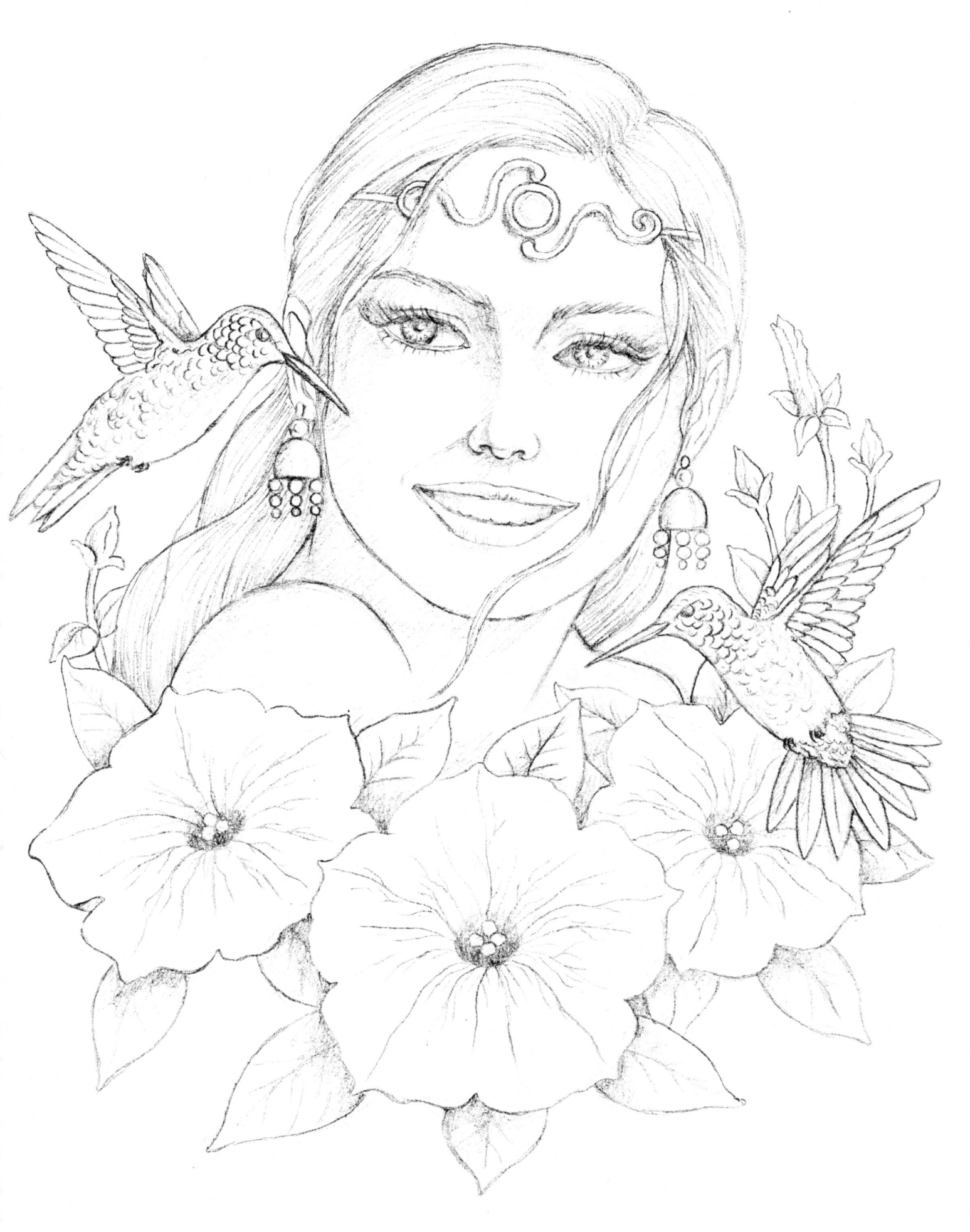

## Auricomus's Stare

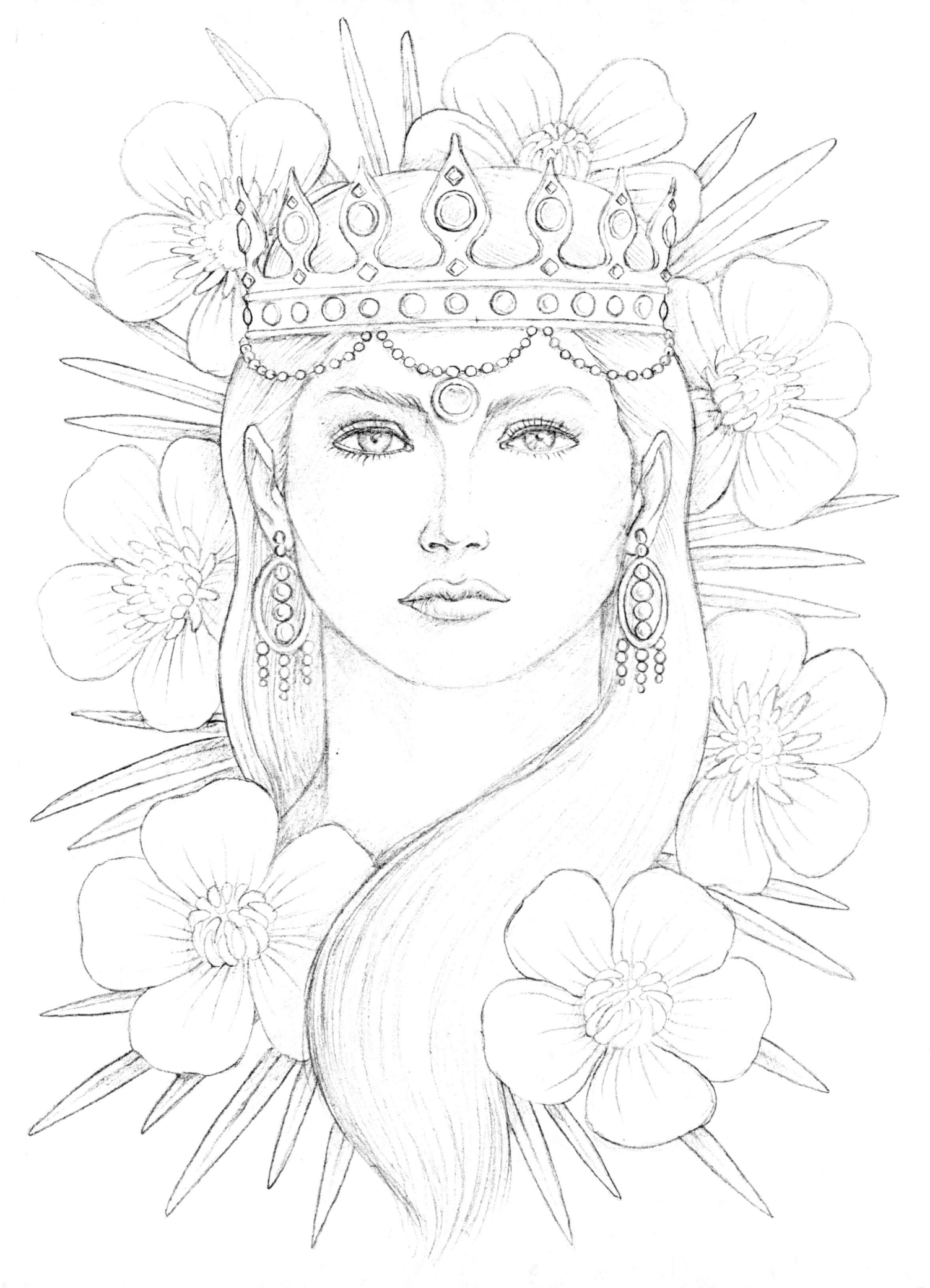

# Arnica

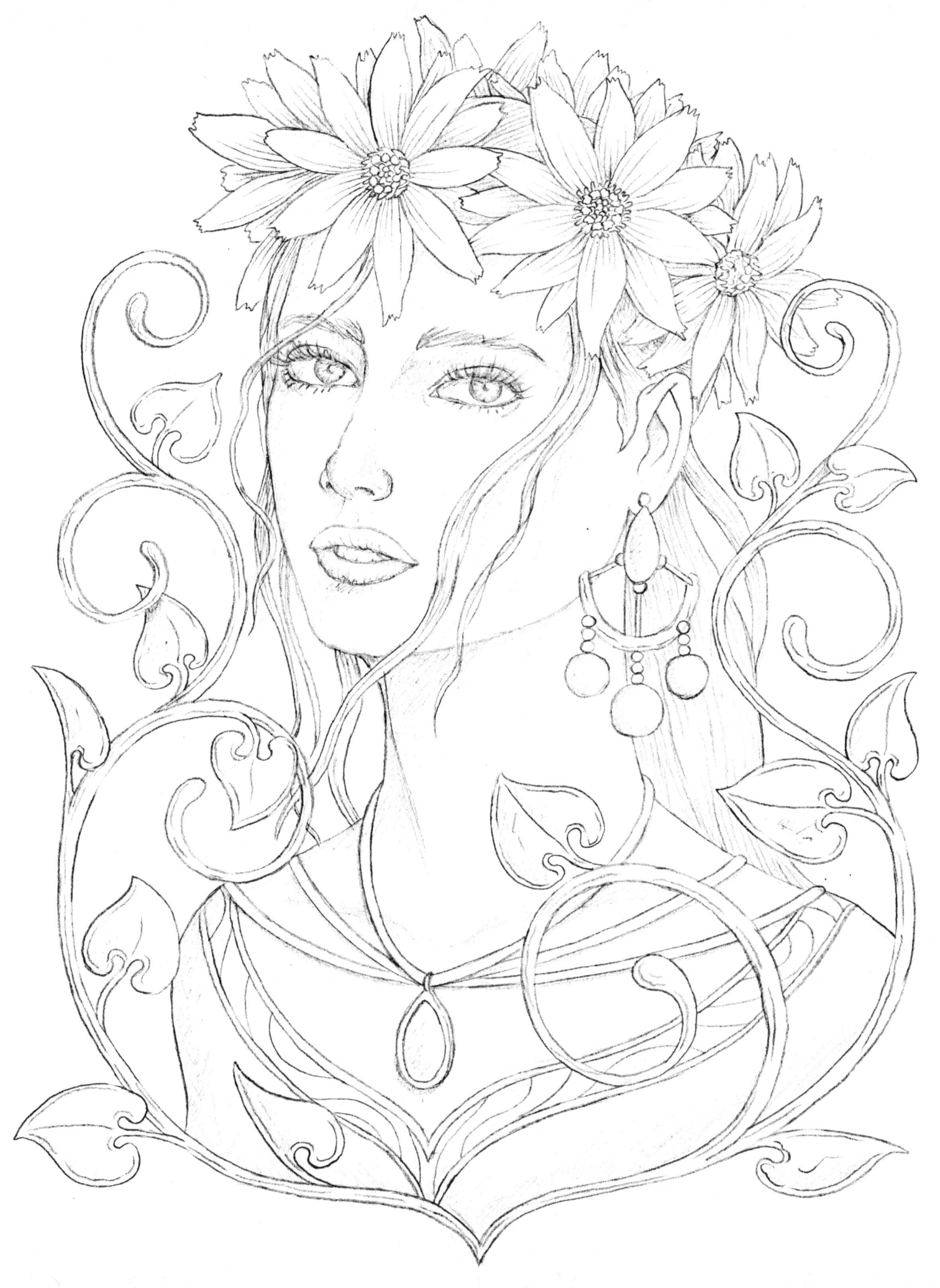

PAPILIONOIDEA'S DREAM

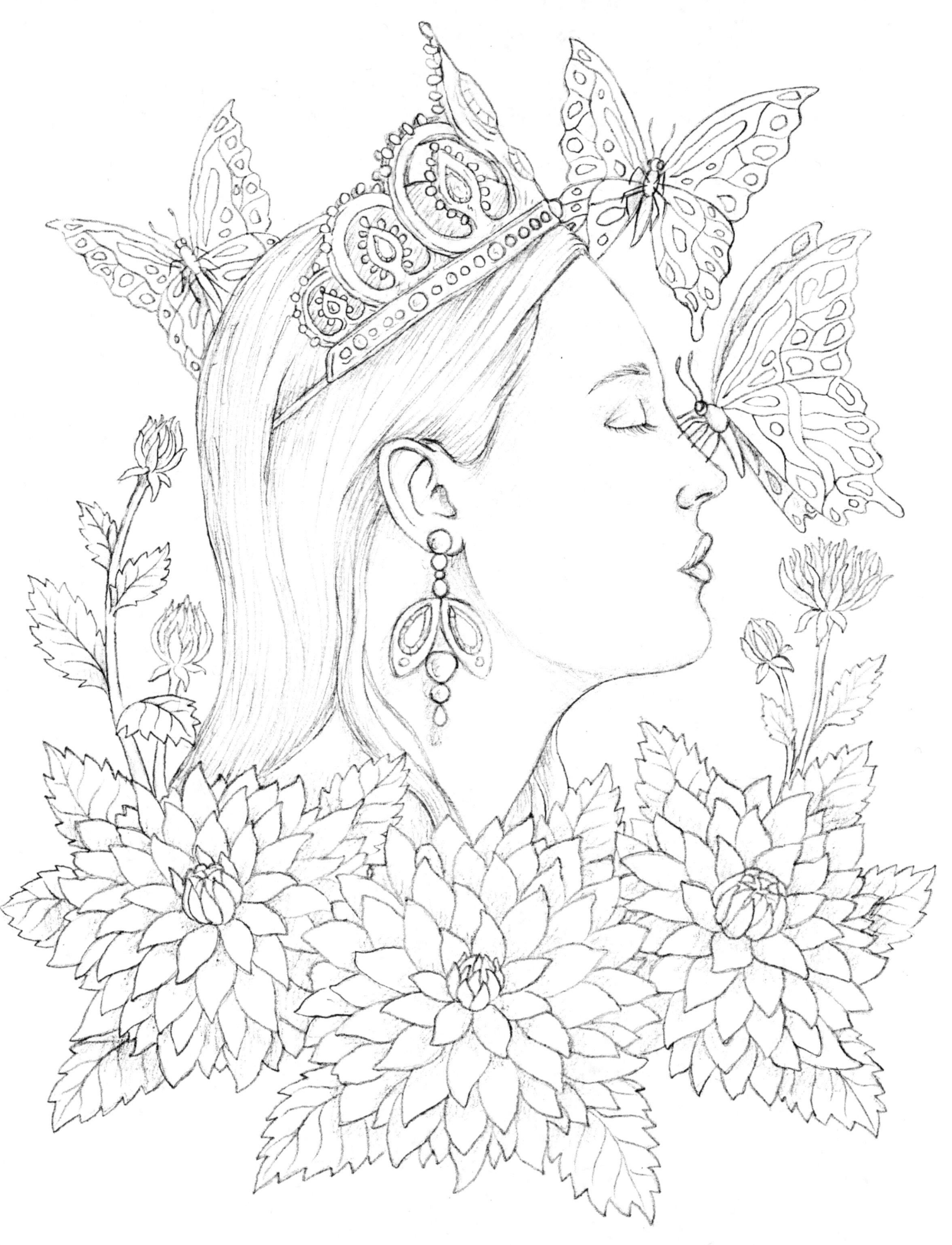

# Spider's Lair

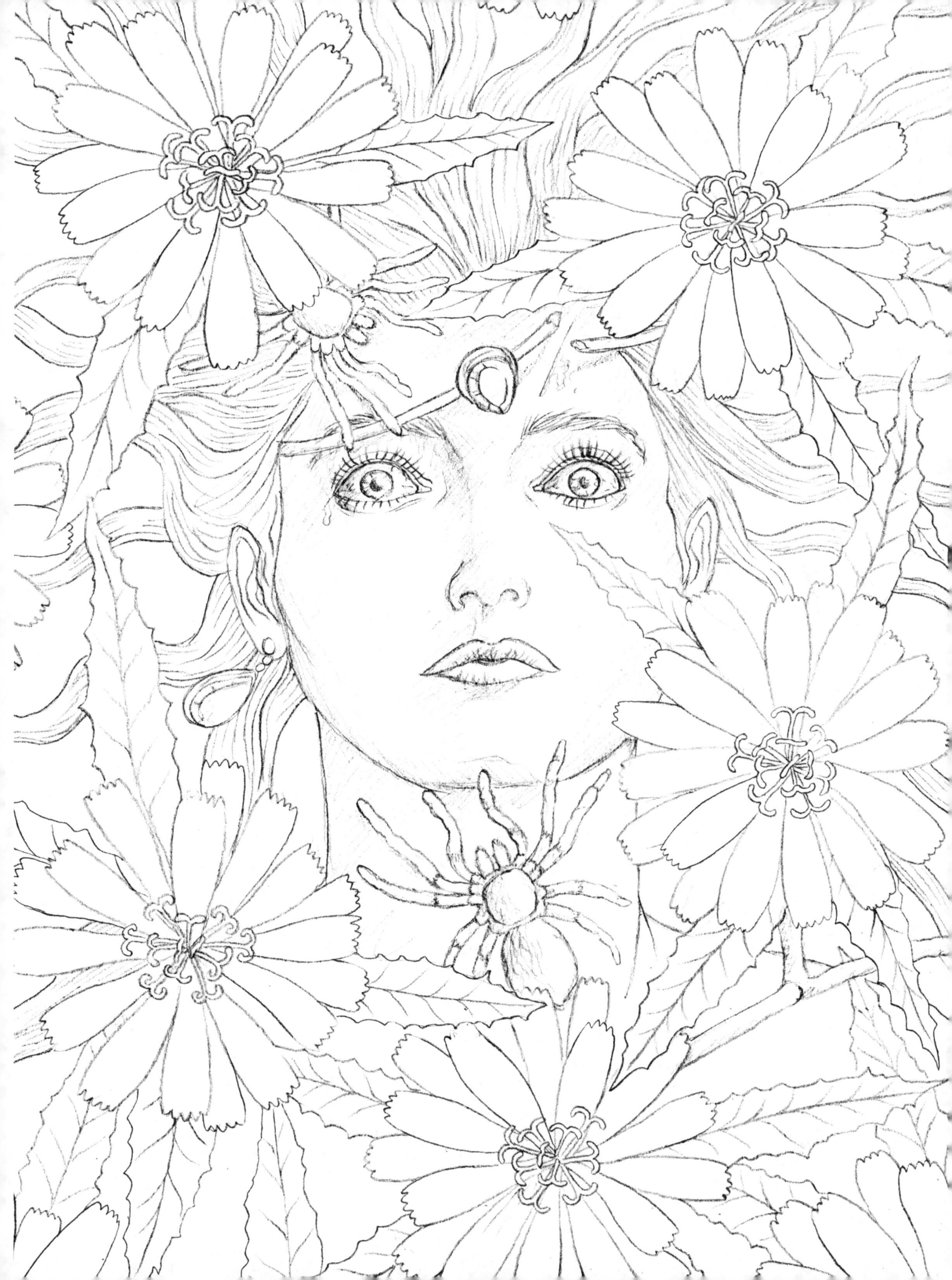

## Falling Feathers

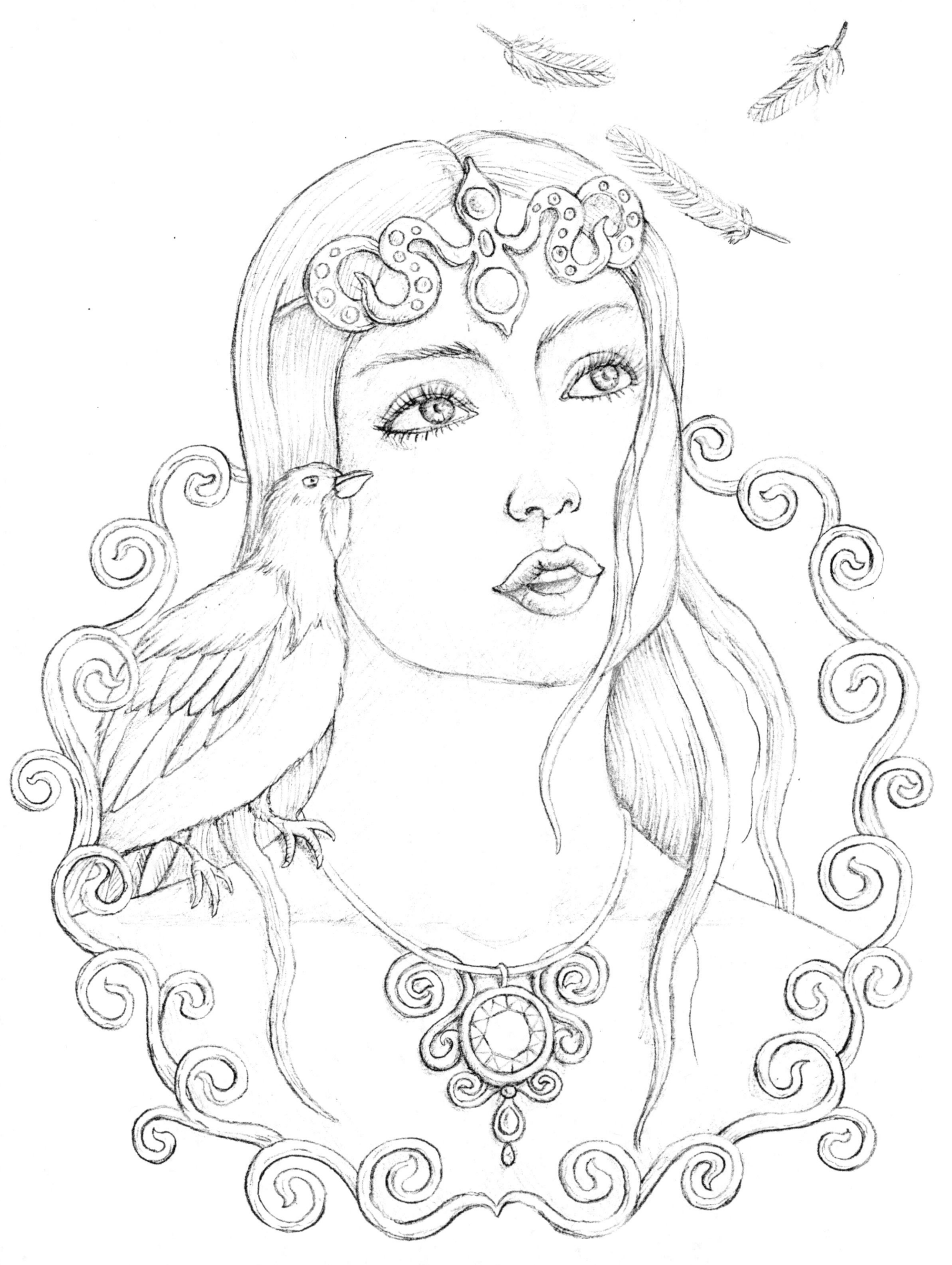

## Flowery Gale

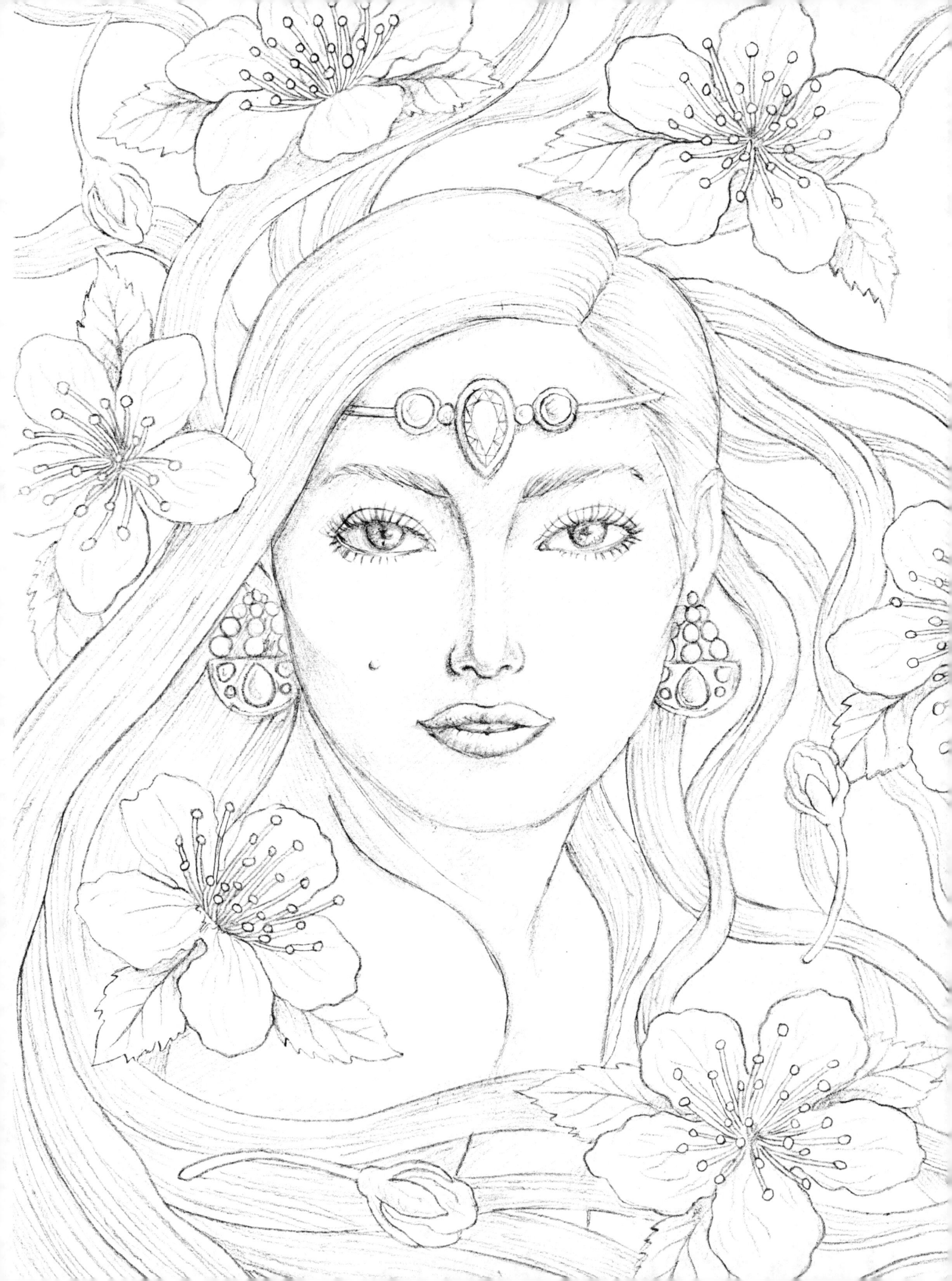

# Faith in the Stars

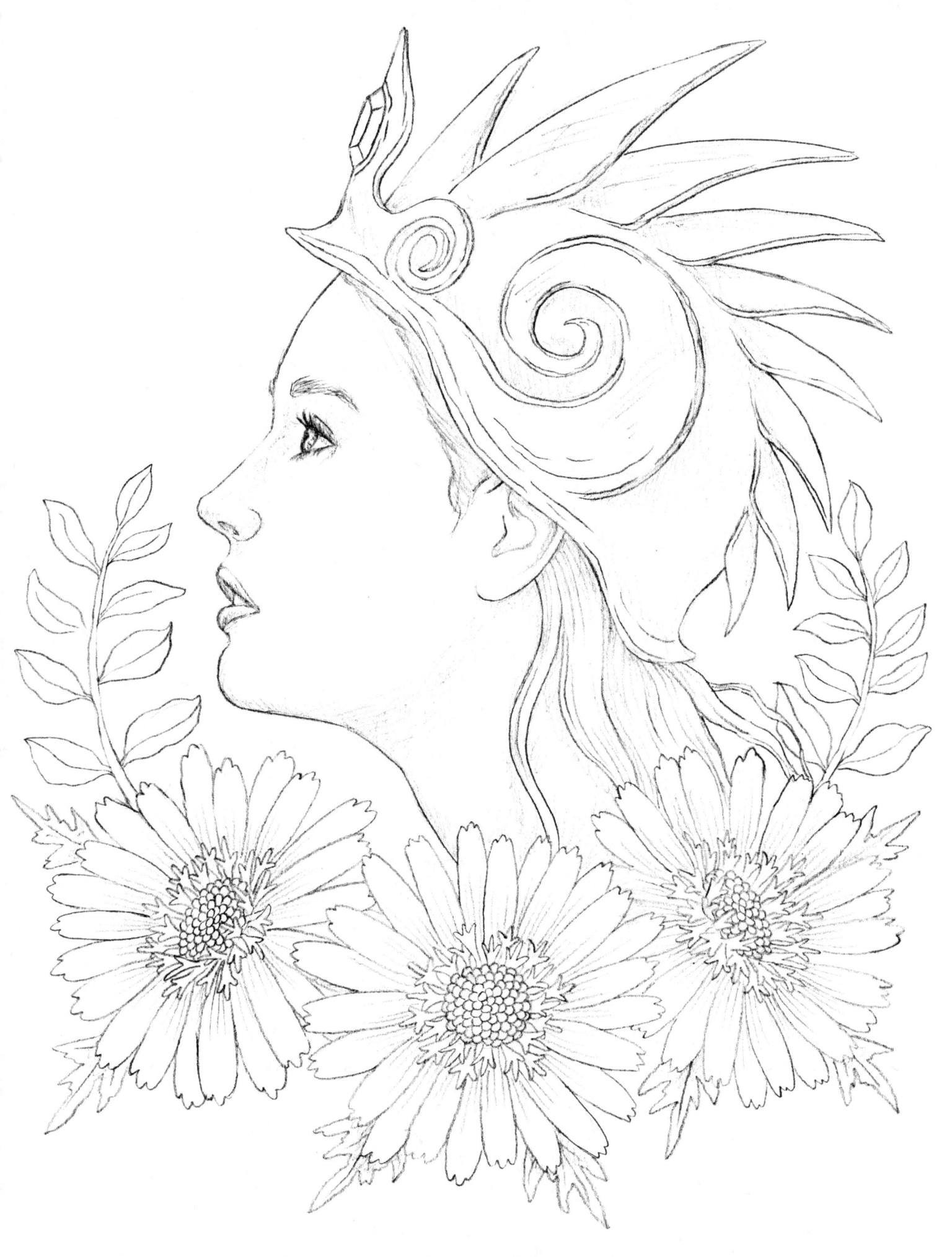

# Heavy Crown

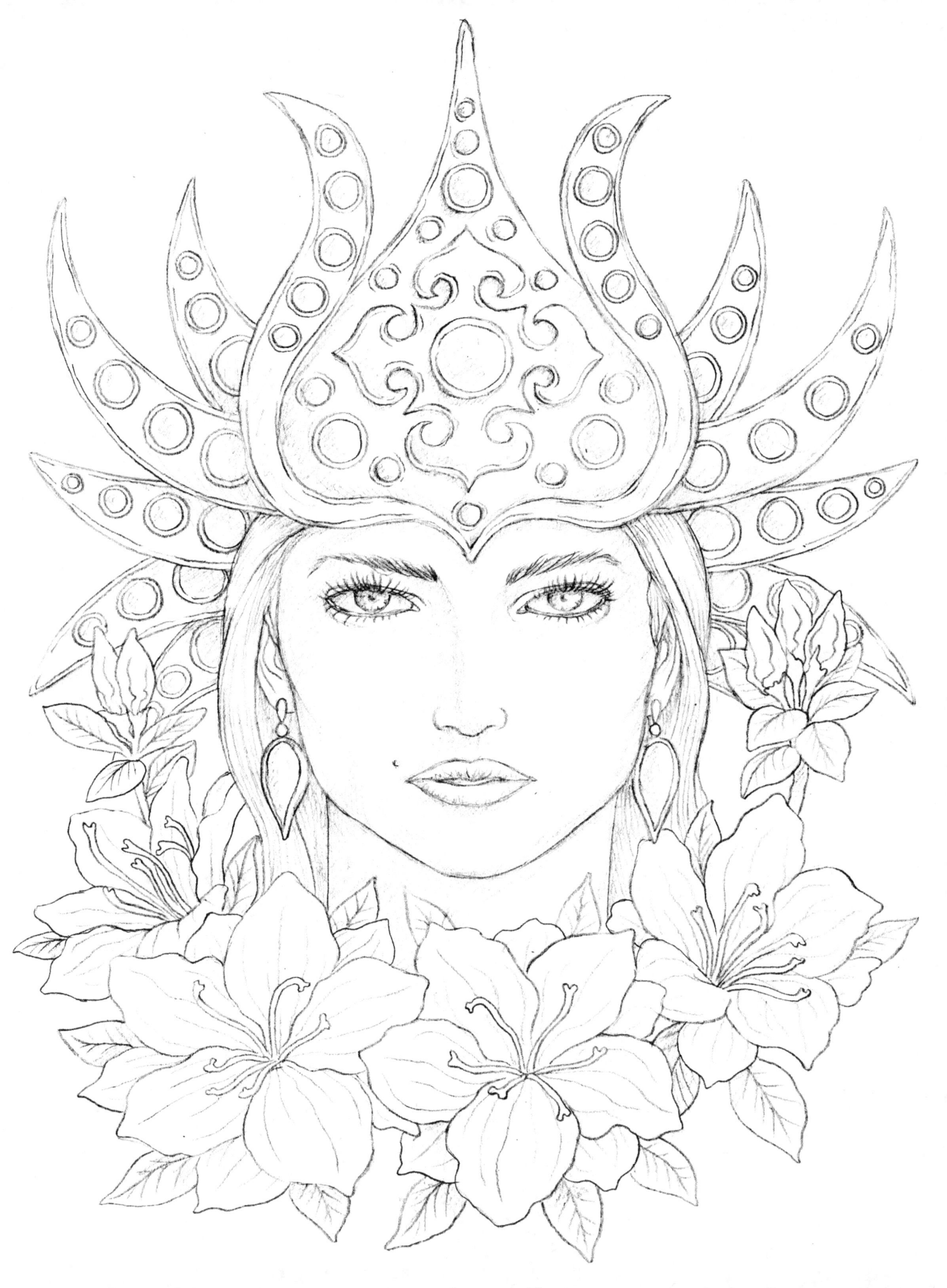

# The Strangler

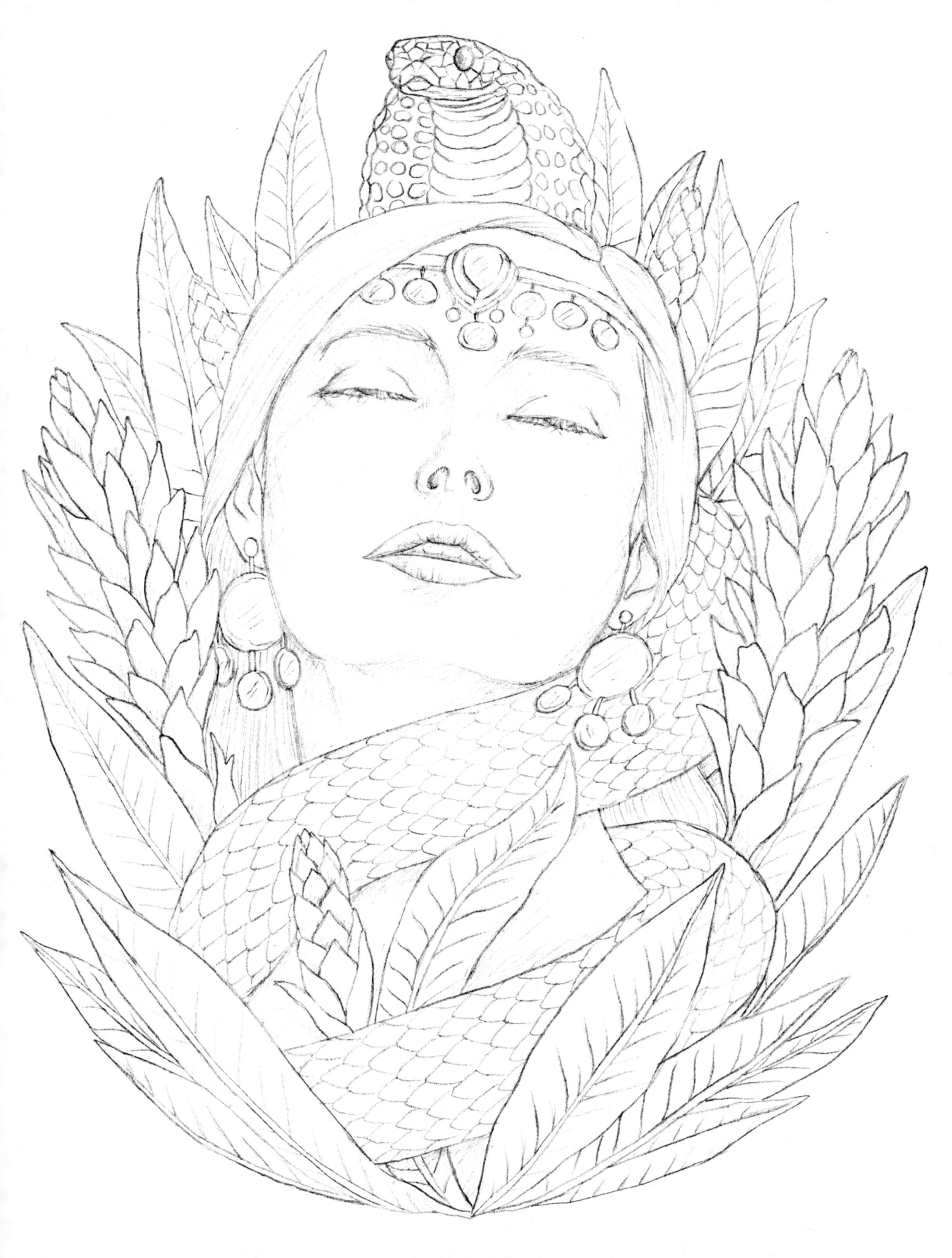

## Leona's War

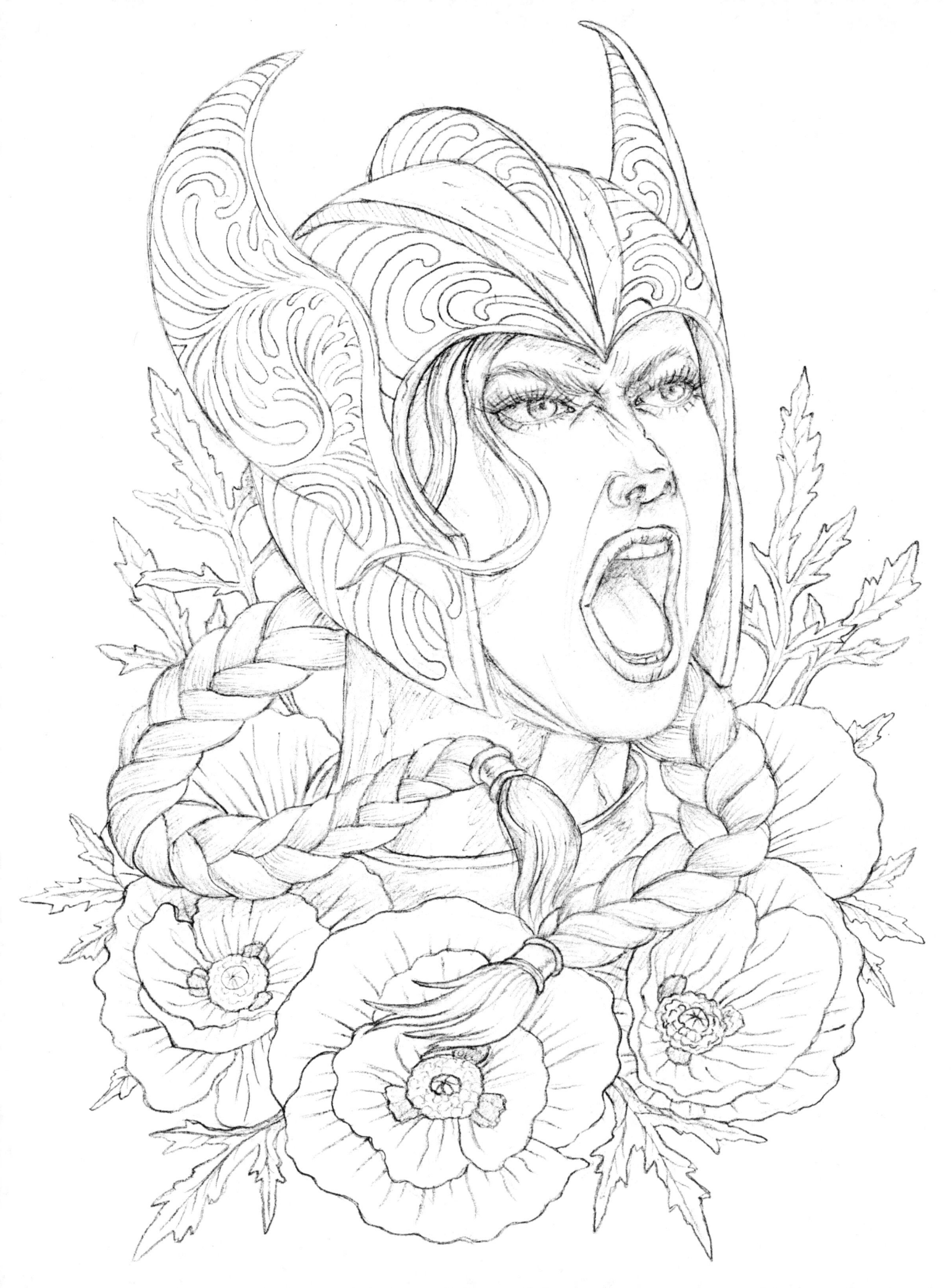

## Fawn's Deer

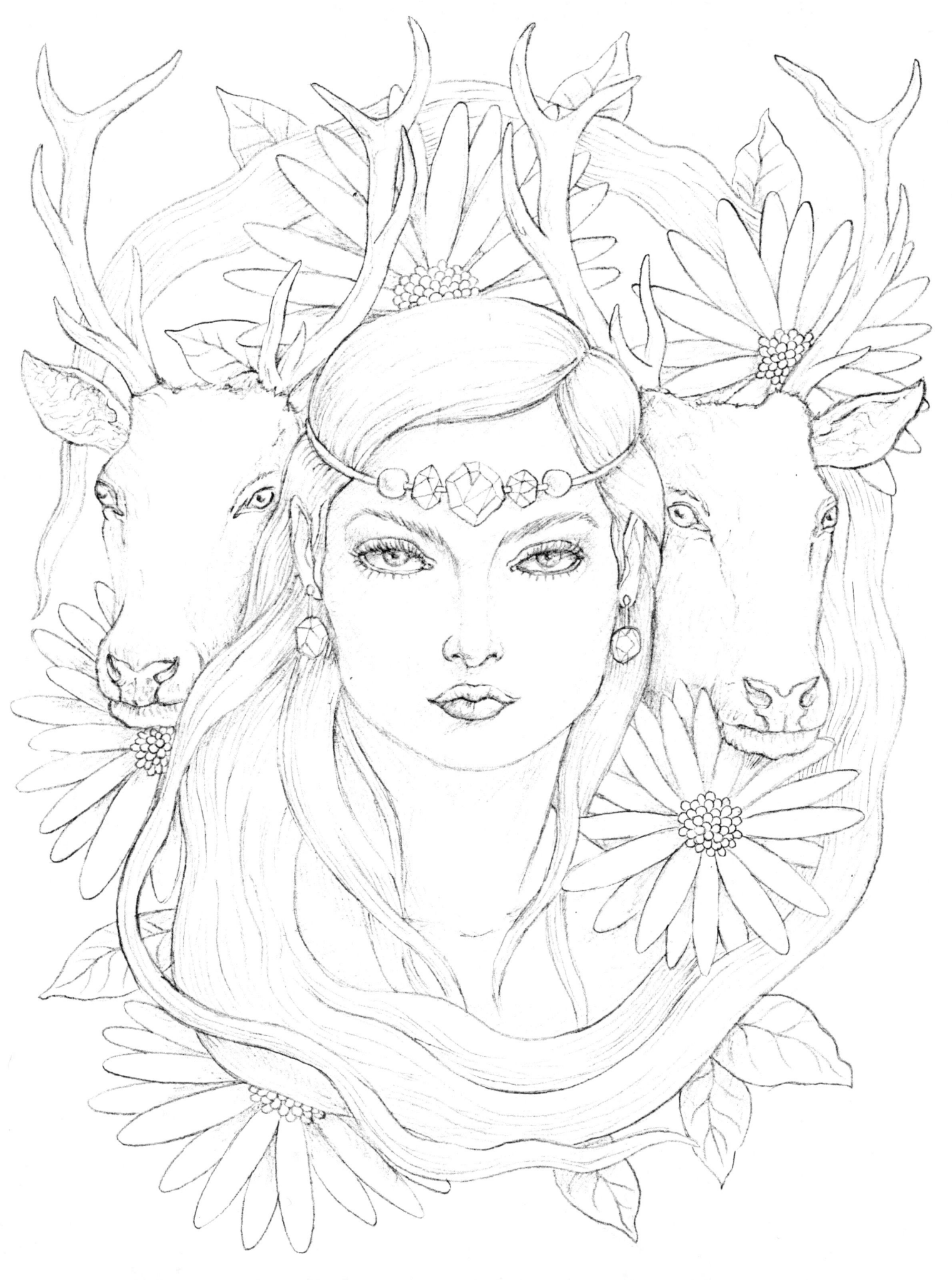

## Princess & the Frog

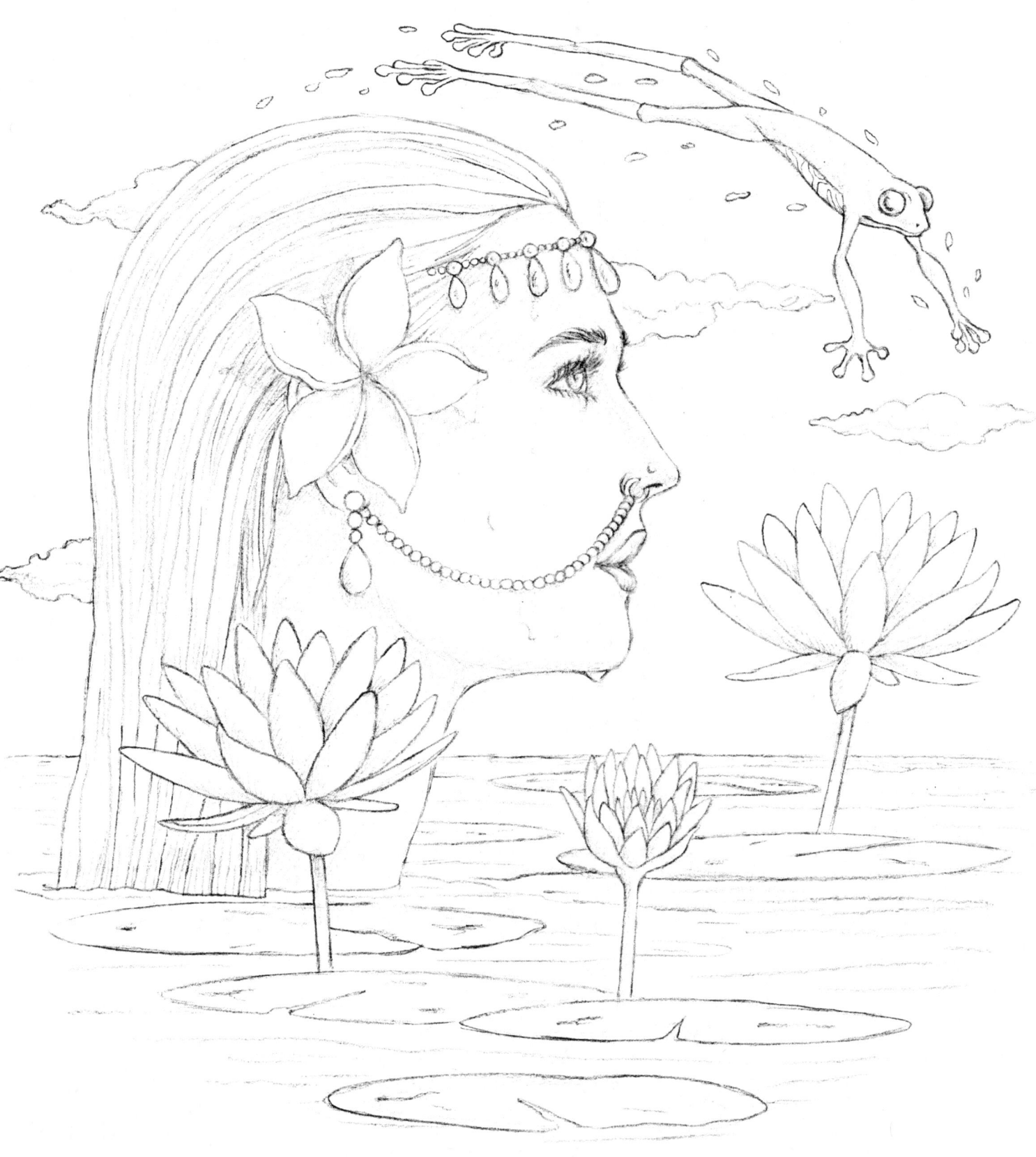

# Queen Apoidea

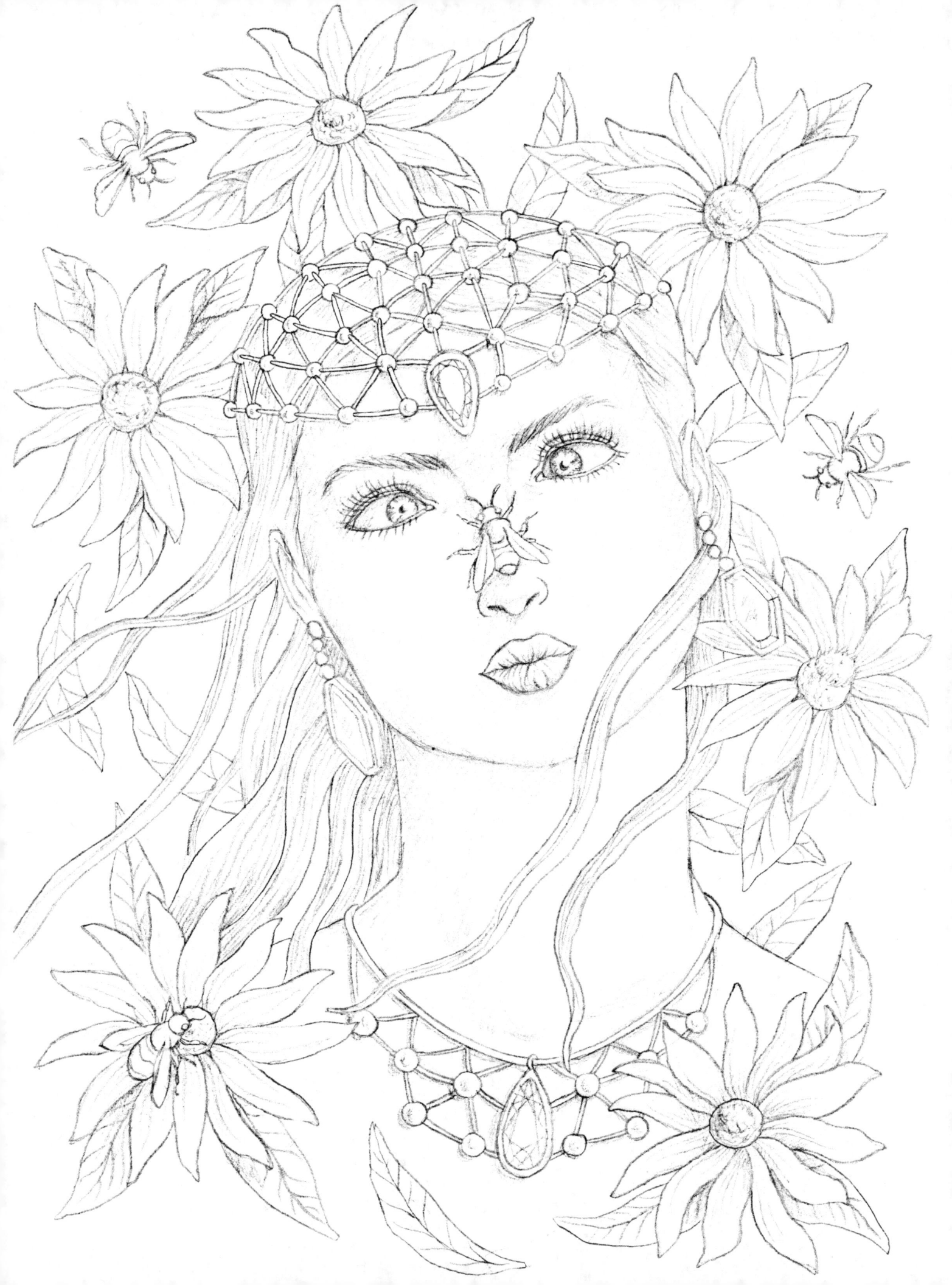

# DRAGON SLAYER

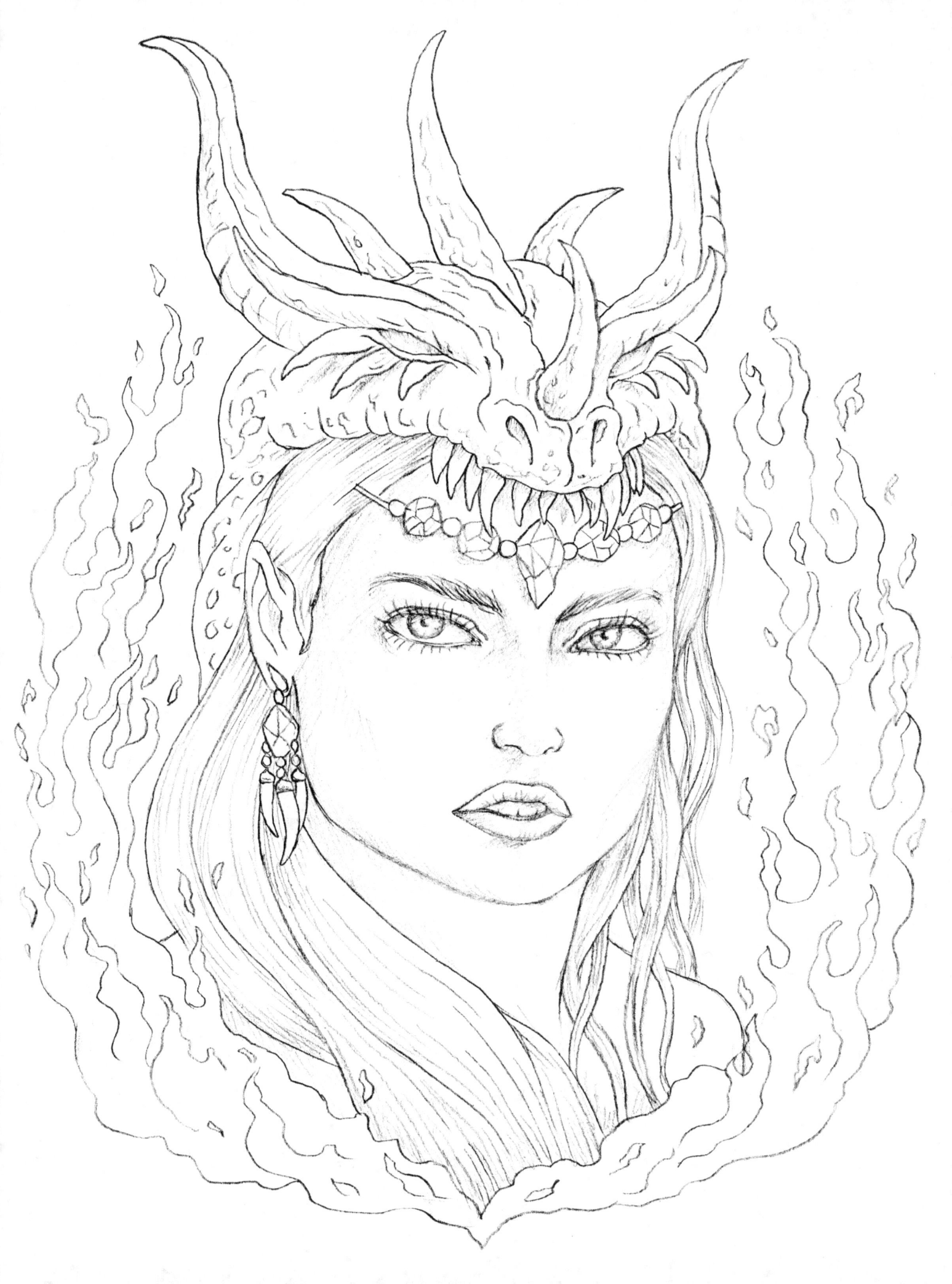

# The Messenger

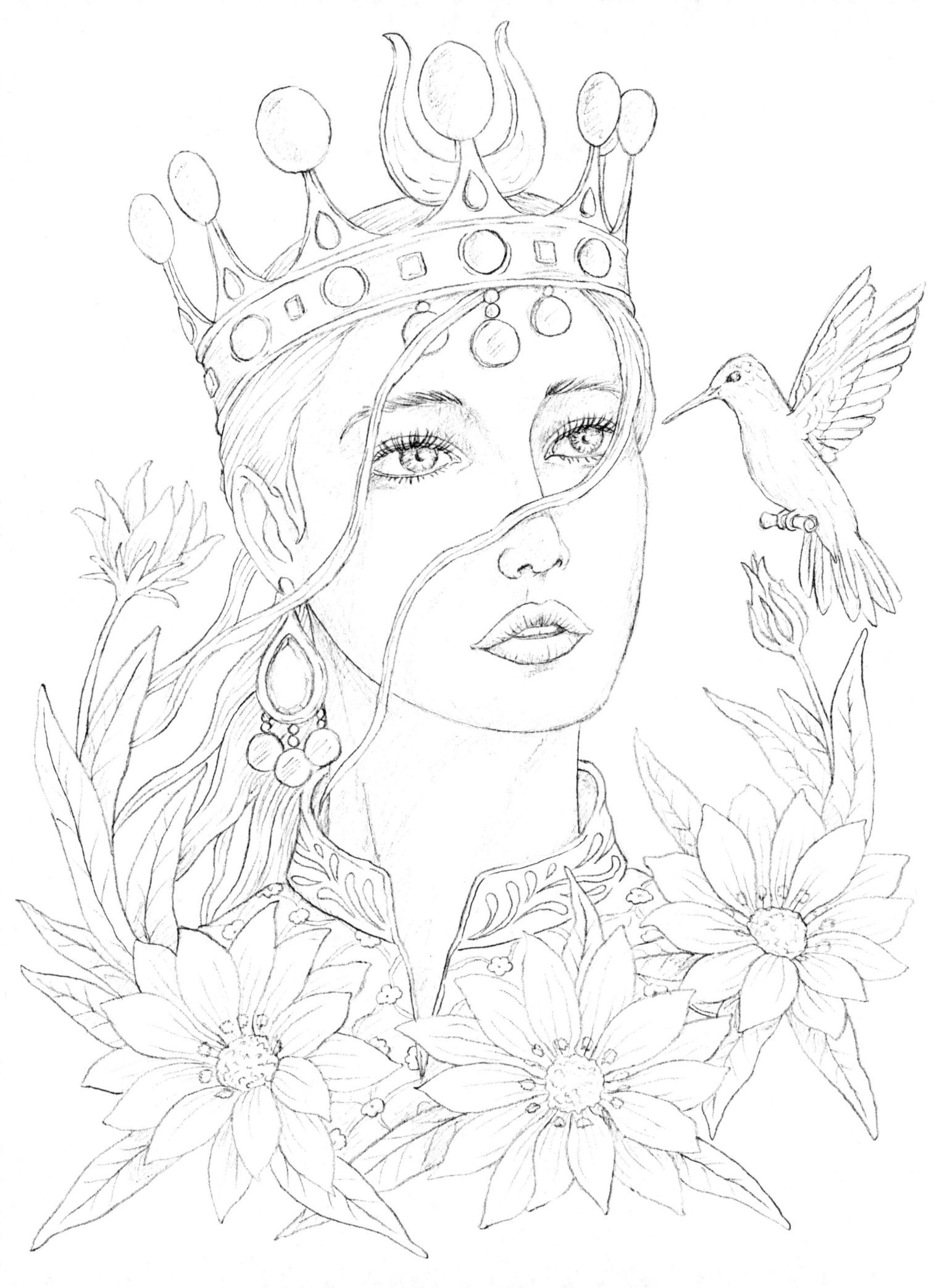

## Raven Ruler #2

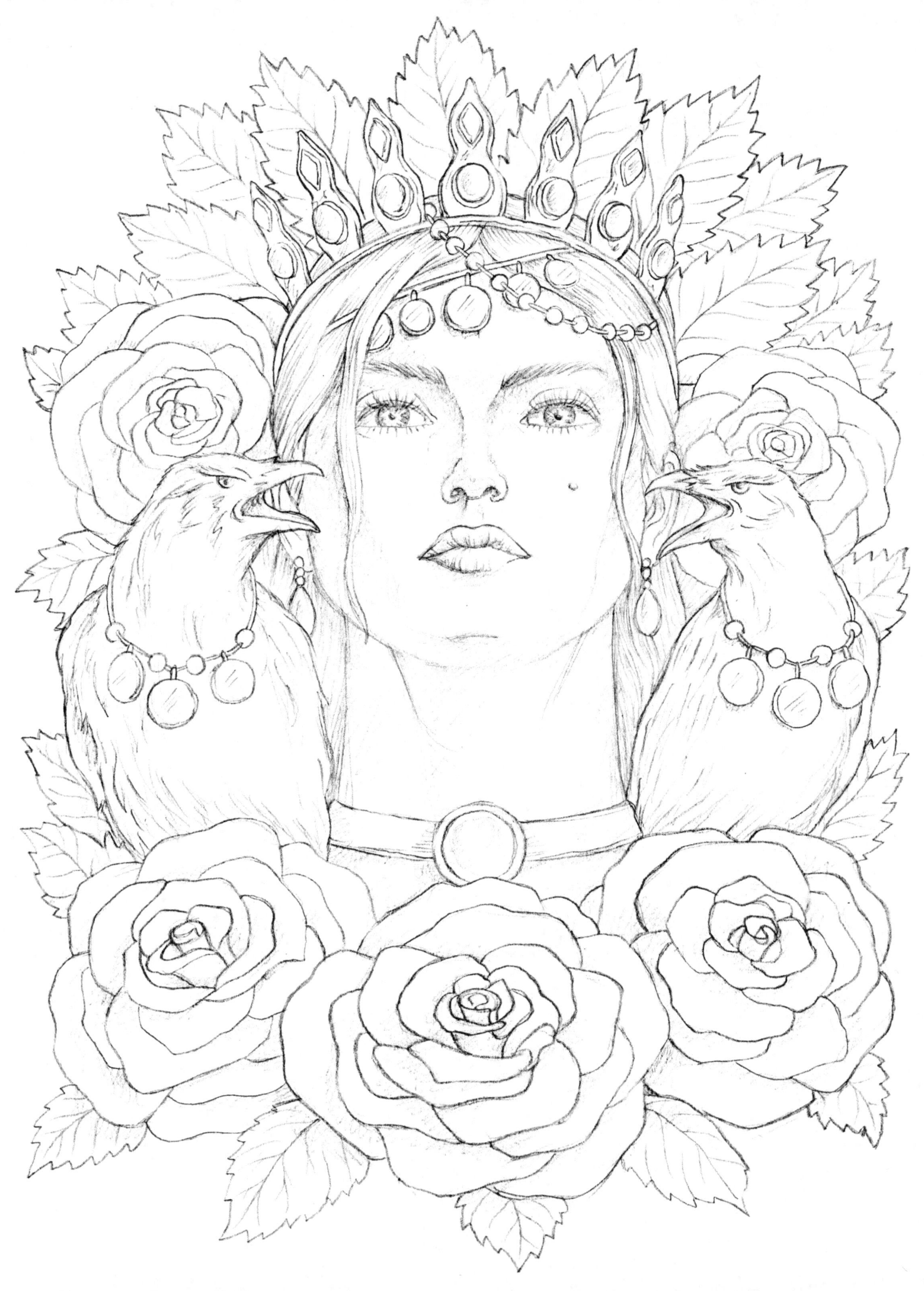

# Water's Spirit

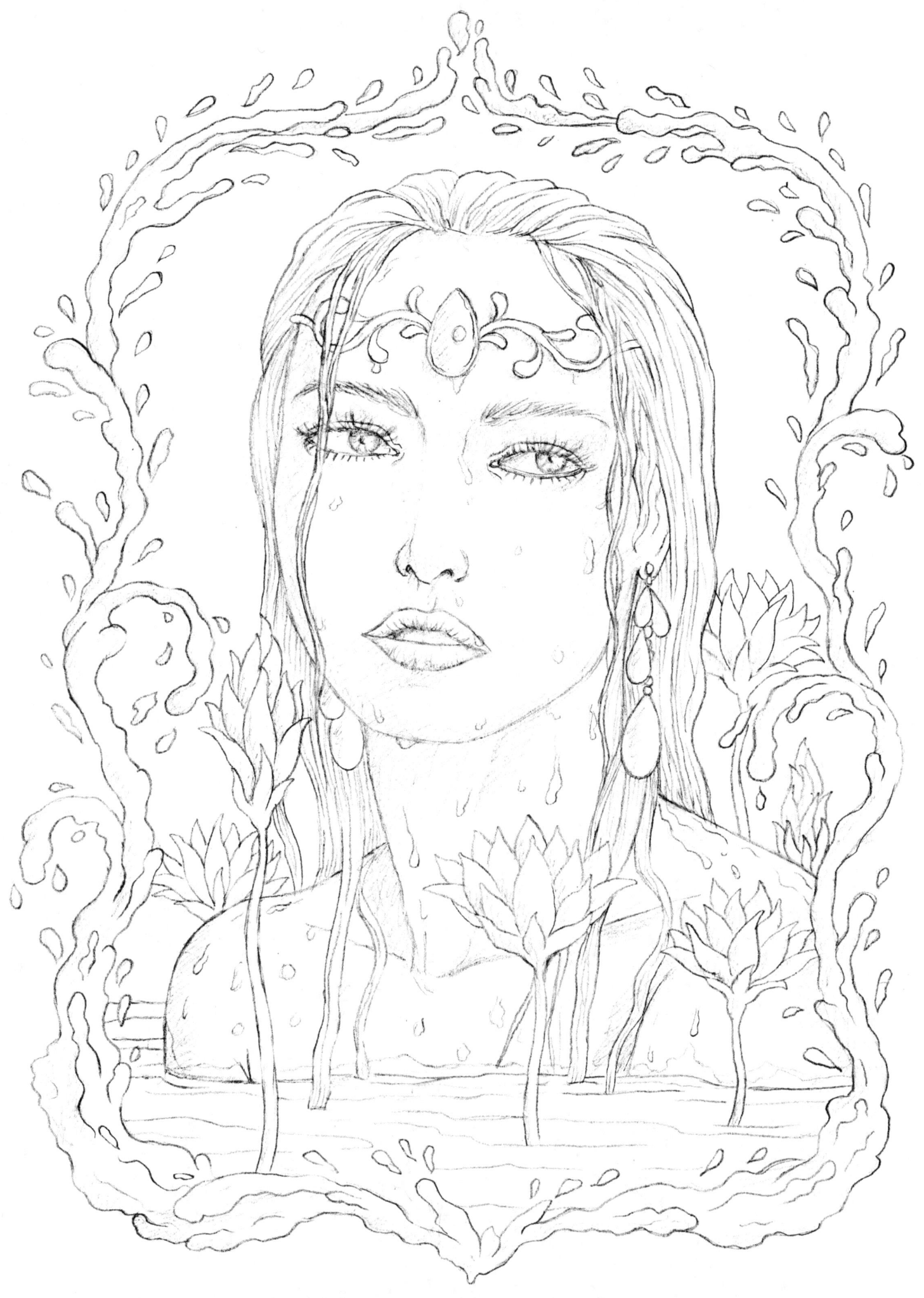

## Savannah Sun

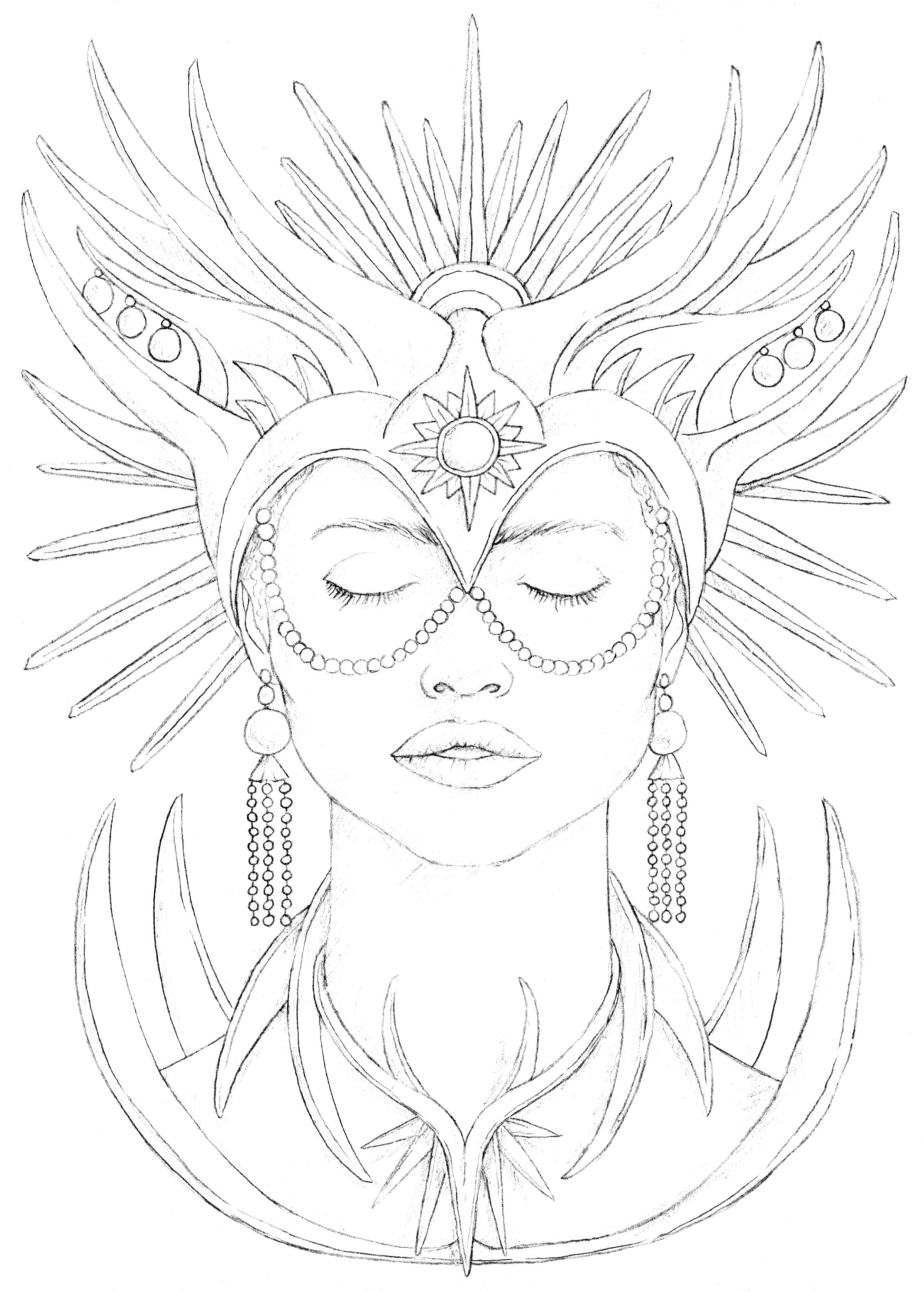

# The Lookout

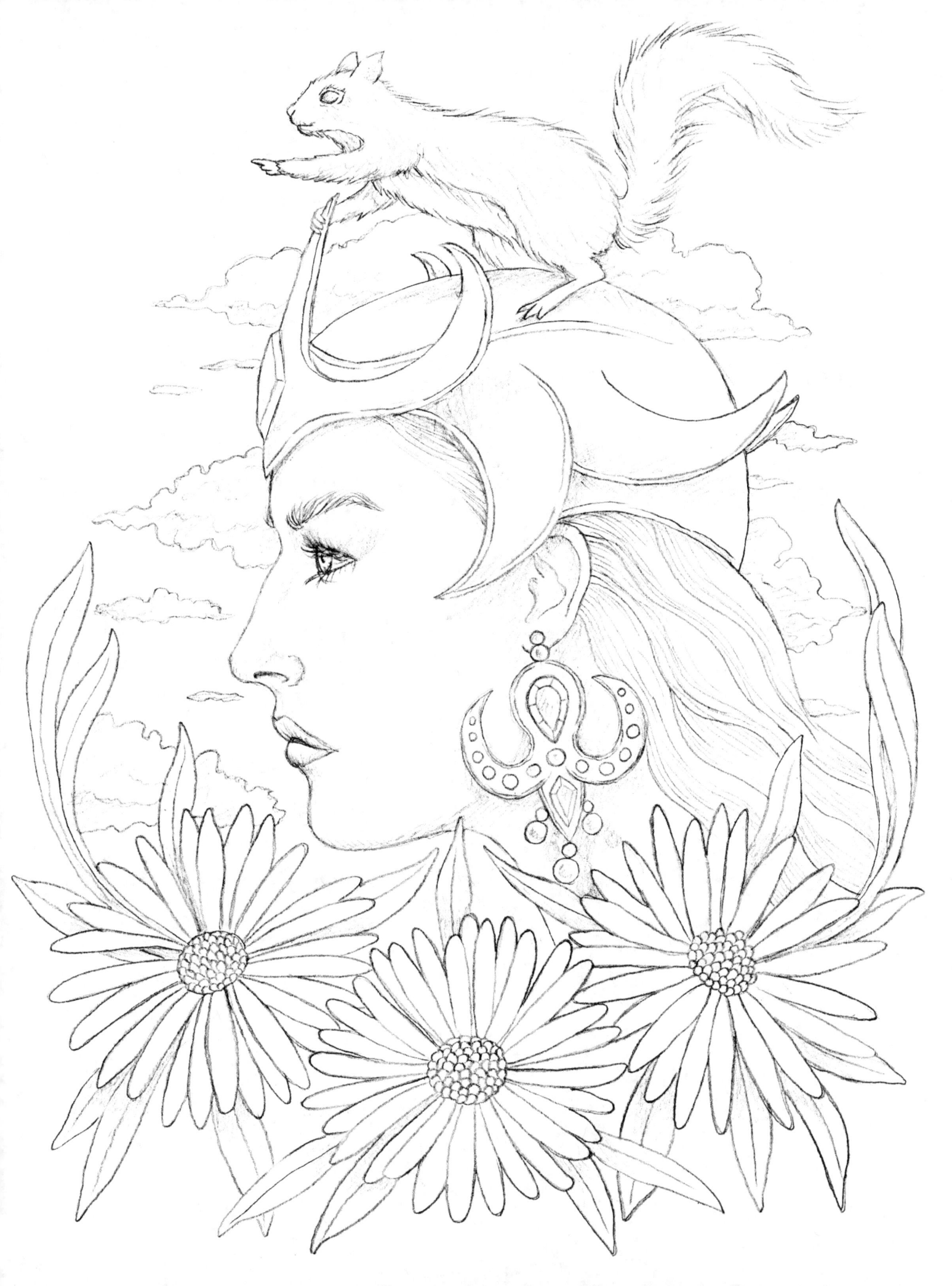

## Queen Lepidoptera

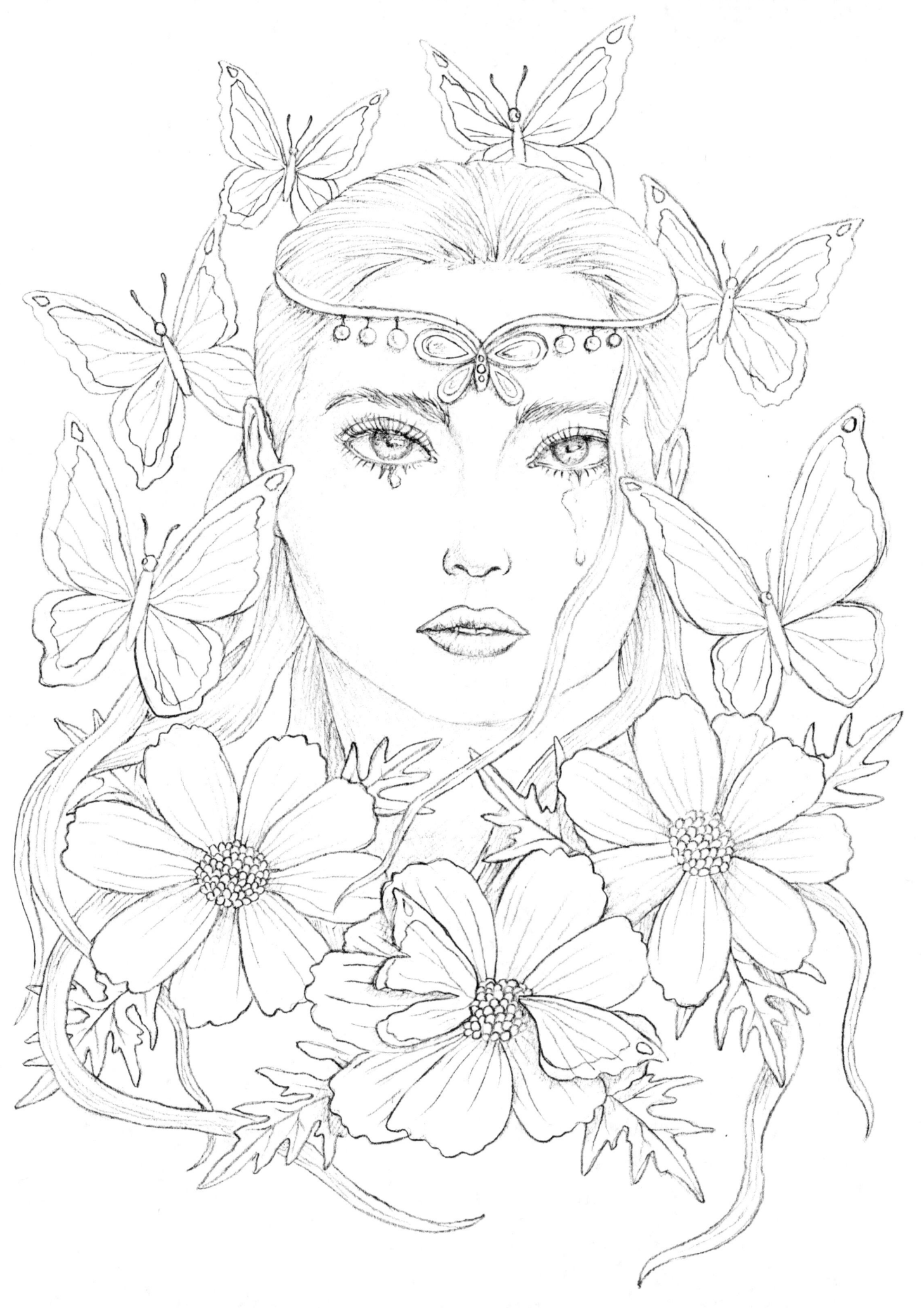

# Reptilian Queen

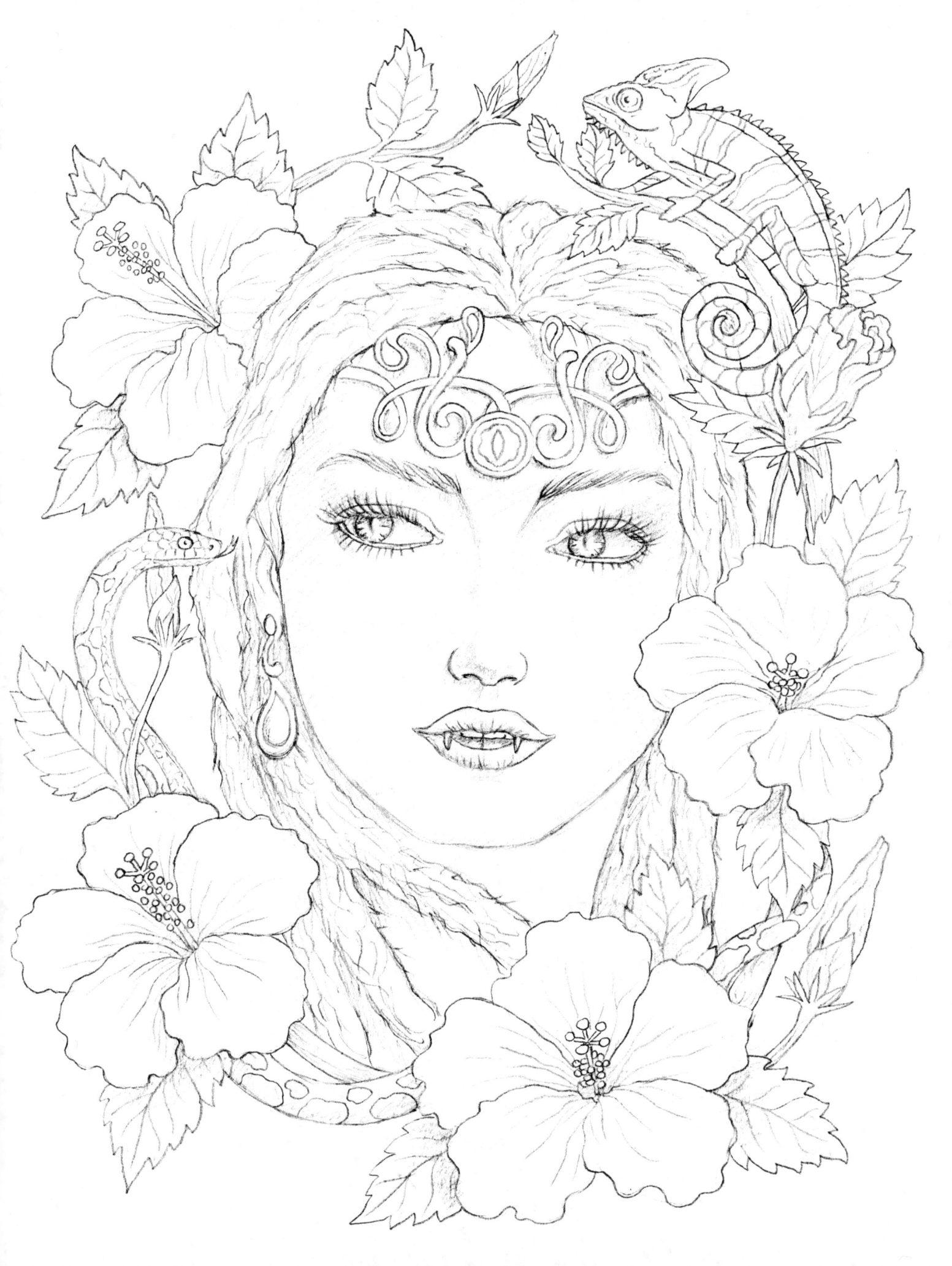

## Red Indian Showers

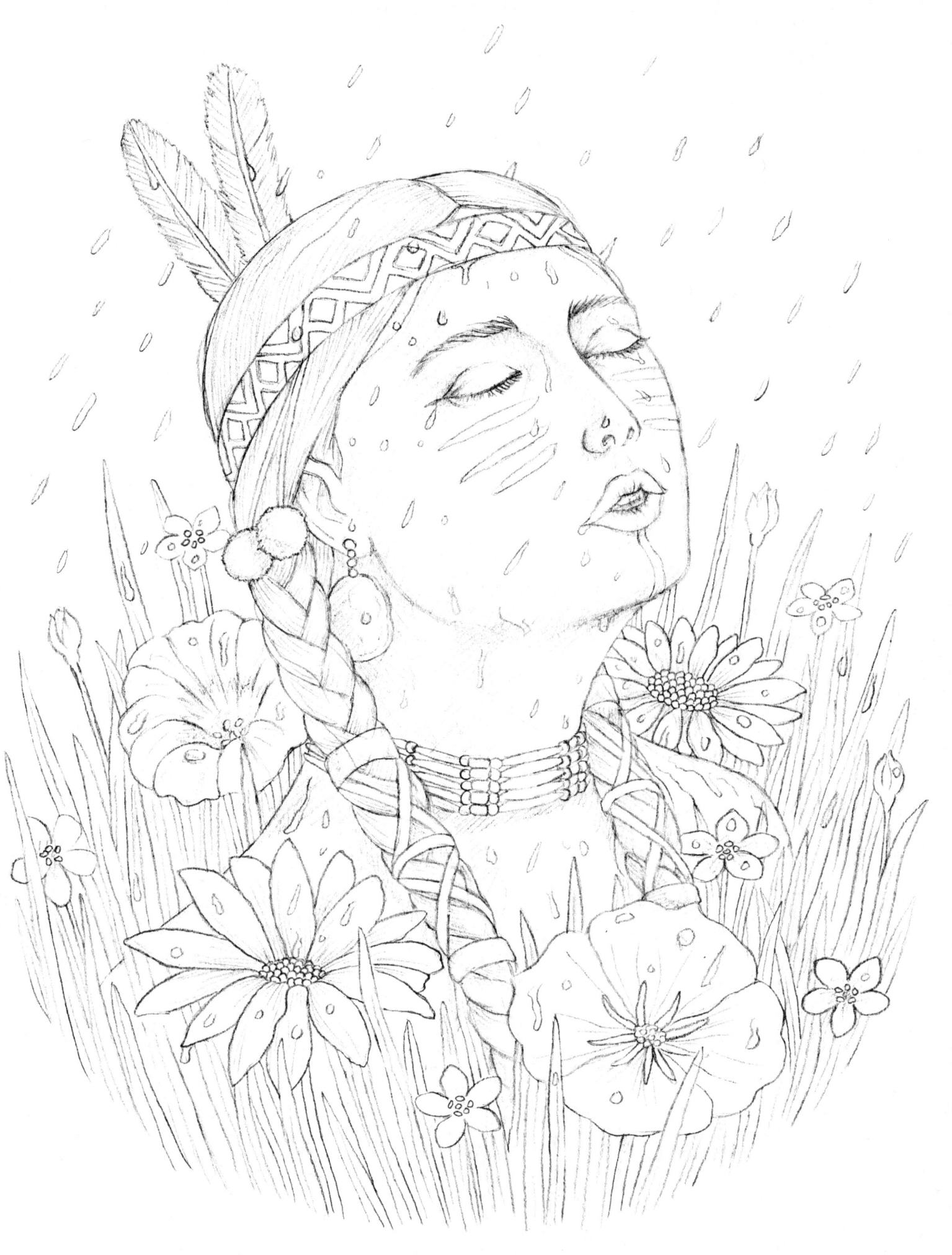

## Hide & Seek

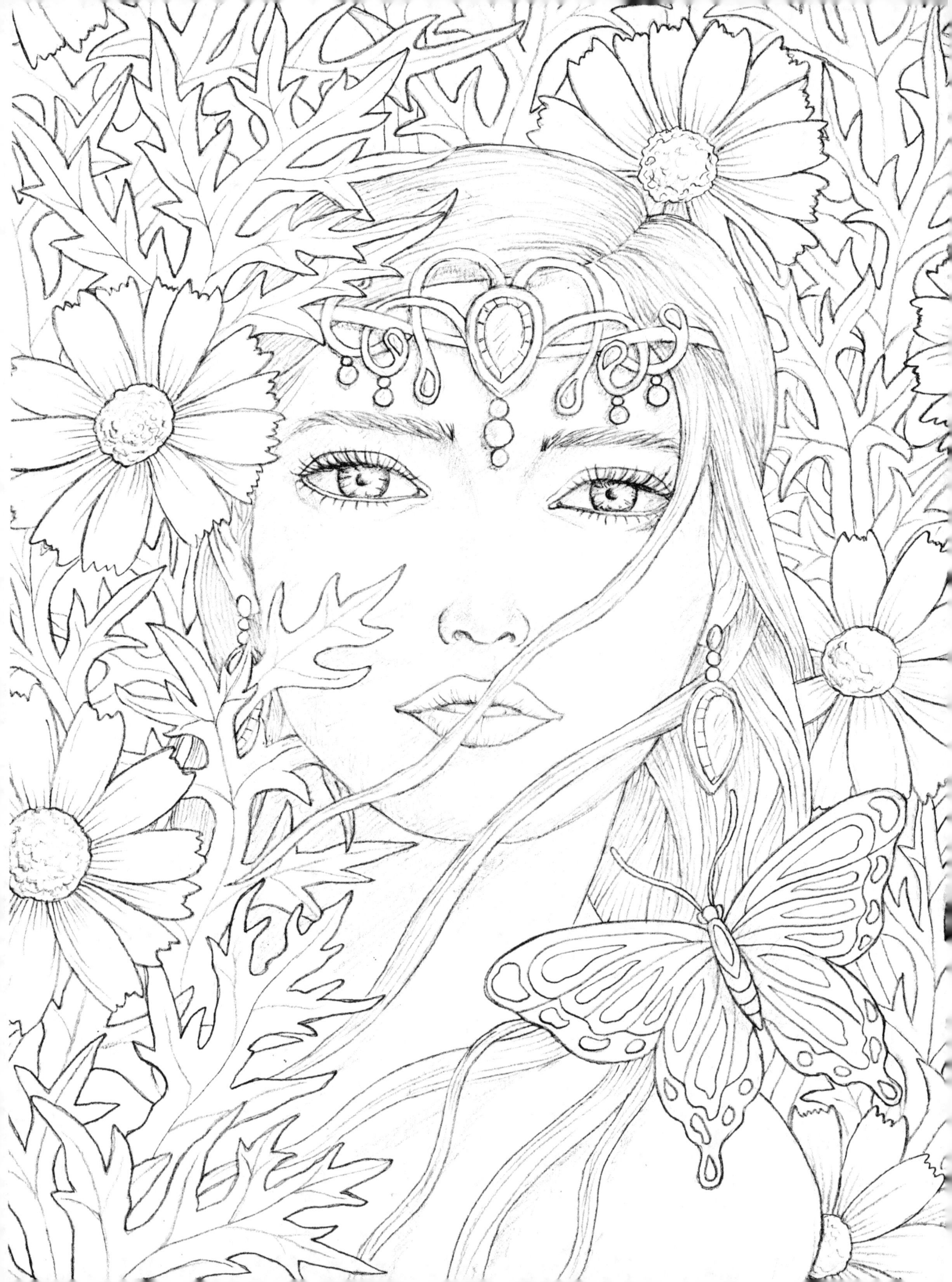

# ALSO AVAILABLE FROM VIVID PUBLISHERS

August Reverie

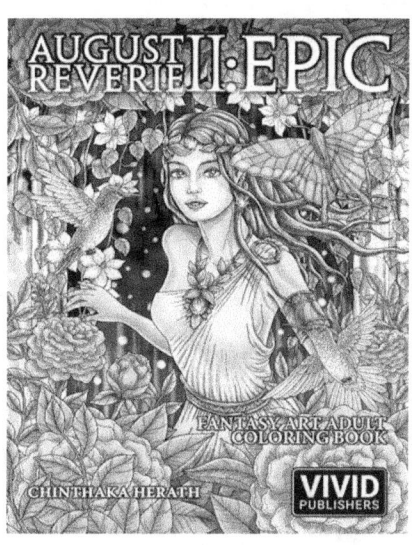

August Reverie 2: Epic

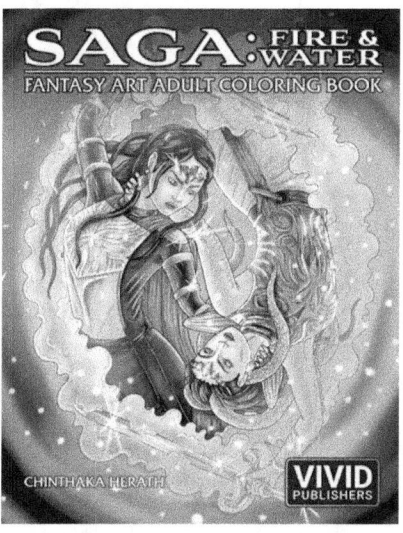

Saga: Fire & Water

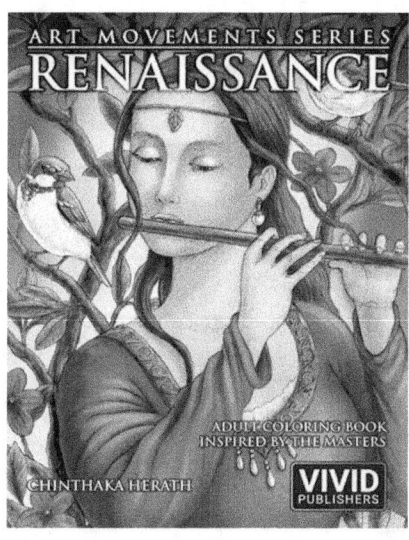

Art Movements Series: Renaissance

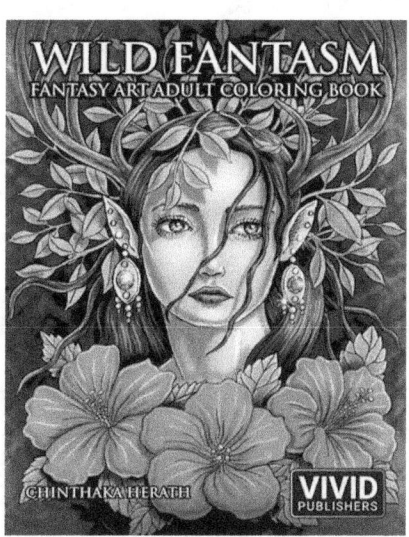

Wild Fantasm

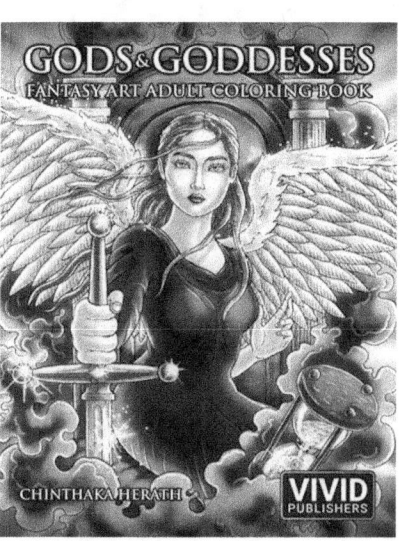

Gods & Goddesses

Preview all the pages at www.vividpublishers.com/books

www.ingramcontent.com/pod-product-compliance
Lightning Source LLC
Chambersburg PA
CBHW082020230526
45466CB00022B/2790